MW00813245

FOUR OTTERS TOBOGGAN

AN ANIMAL COUNTING BOOK

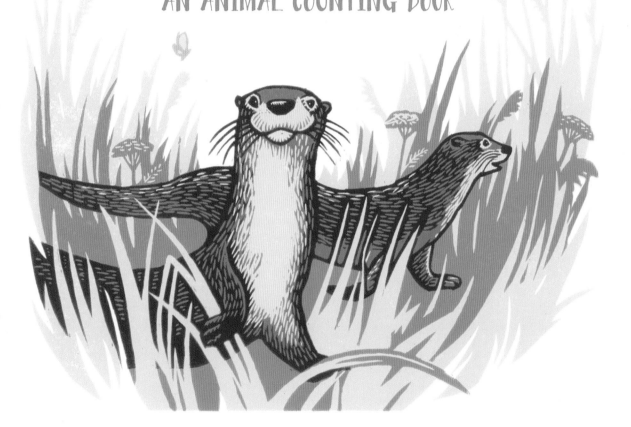

Written by
VIVIAN KIRKFIELD

Illustrated by
MIRKA HOKKANEN

Pomegranate **kids**

PORTLAND, OREGON

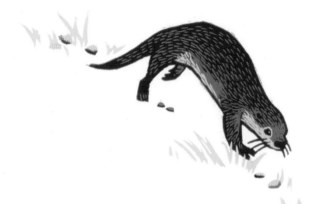

Published by PomegranateKids®, an imprint of
Pomegranate Communications, Inc.
19018 NE Portal Way, Portland, OR 97230
800-227-1428 www.pomegranate.com

Pomegranate Europe
Number 3 Siskin Drive
Middlemarch Business Park
Coventry, CV3 4FJ, UK
+44 (0)24 7621 4461 sales@pomegranate.com

To learn about new releases and special offers from Pomegranate, please visit www.pomegranate.com
and sign up for our email newsletter. For all other queries, see "Contact Us" on our home page.

Text © 2019 Vivian Kirkfield
Illustrations © 2019 Mirka Hokkanen

This product is in compliance with the Consumer Product Safety Improvement Act of 2008 (CPSIA) and
any subsequent amendments thereto. A General Conformity Certificate concerning Pomegranate's
compliance with the CPSIA is available on our website at www.pomegranate.com, or by request at
800-227-1428. For additional CPSIA-required tracking details, contact Pomegranate at 800-227-1428.

Library of Congress Control Number: 2018955756

ISBN 978-0-7649-8435-8

Pomegranate Item No. A280
Designed by Tristen Jackman
Printed in China

28 27 26 25 24 23 22 21 20 19 10 9 8 7 6 5 4 3 2 1

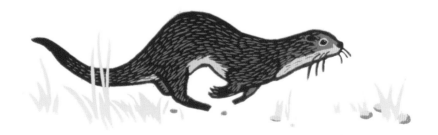

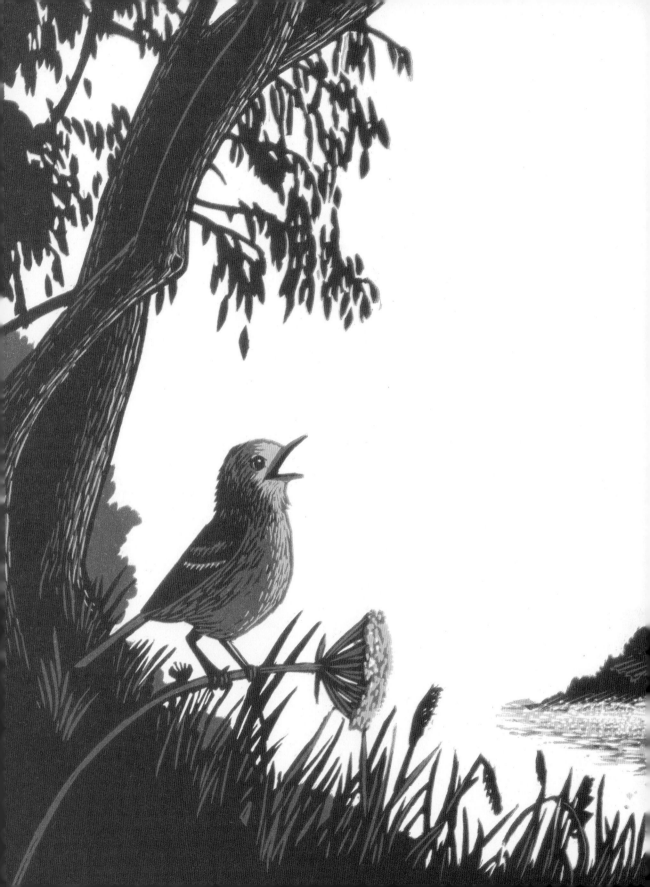

Water waits.
Dawn breaks
in a chorus of bird song.

ONE willow flycatcher whistles
as the night slips silently away.

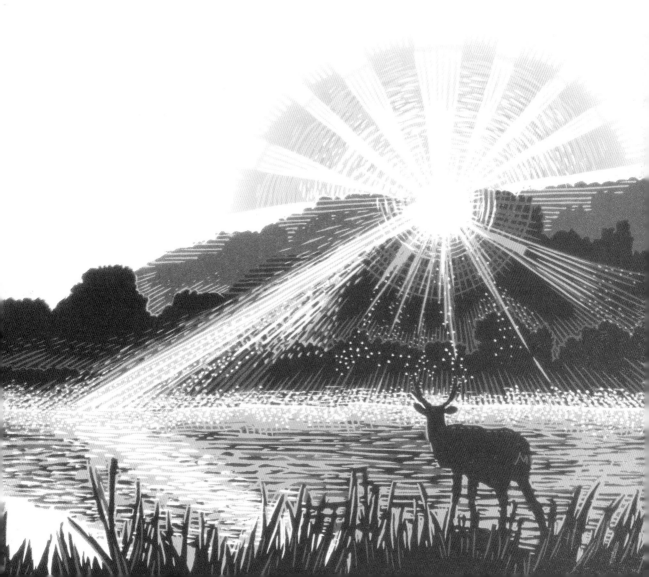

Water ripples.
TWO dragonflies dance,
ballerinas above a liquid stage,

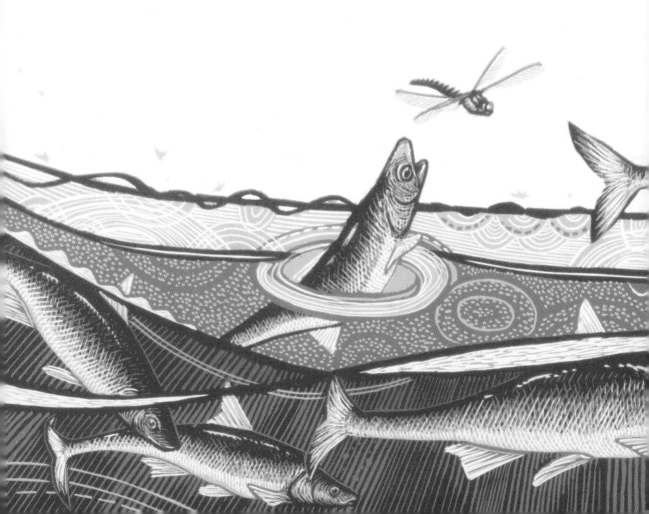

while a school of bonytail chub
leap in a frenzy of feeding.

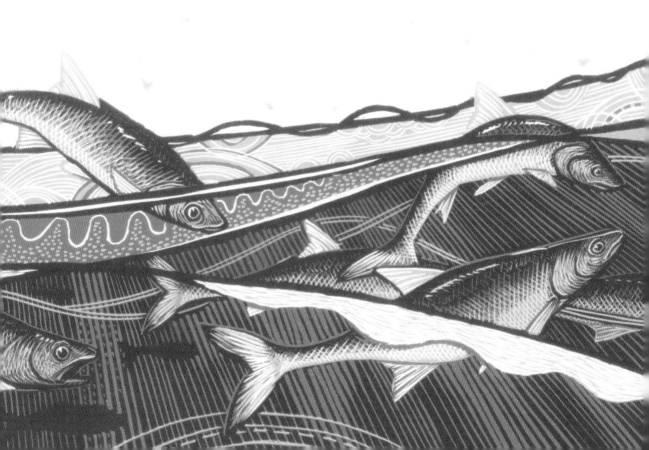

Water calms.
A kit fox tiptoes.

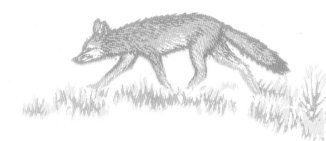

Tucked away in dense brush,
cubs tense for her signal.

Ears twitch. Tails switch.
THREE kits eagerly sit.

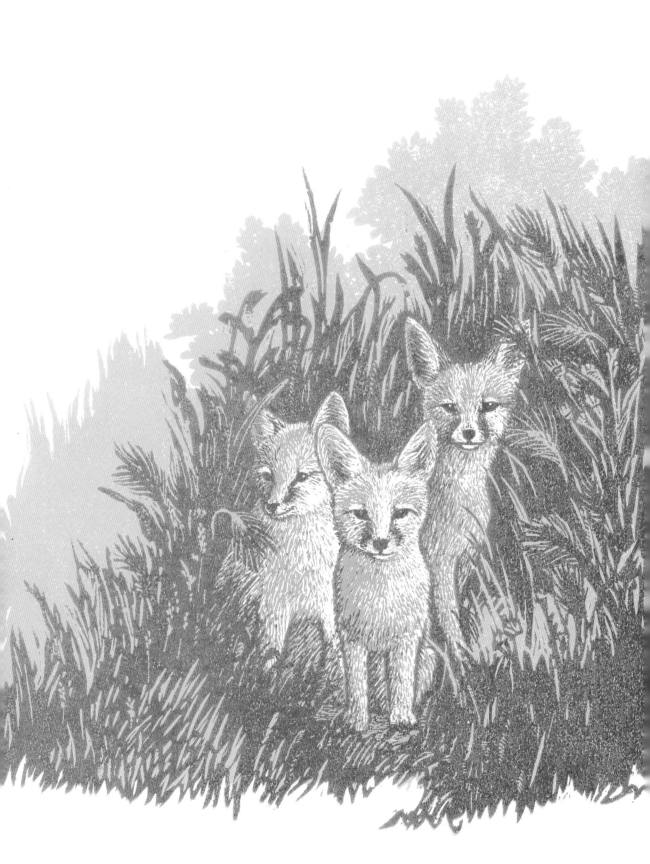

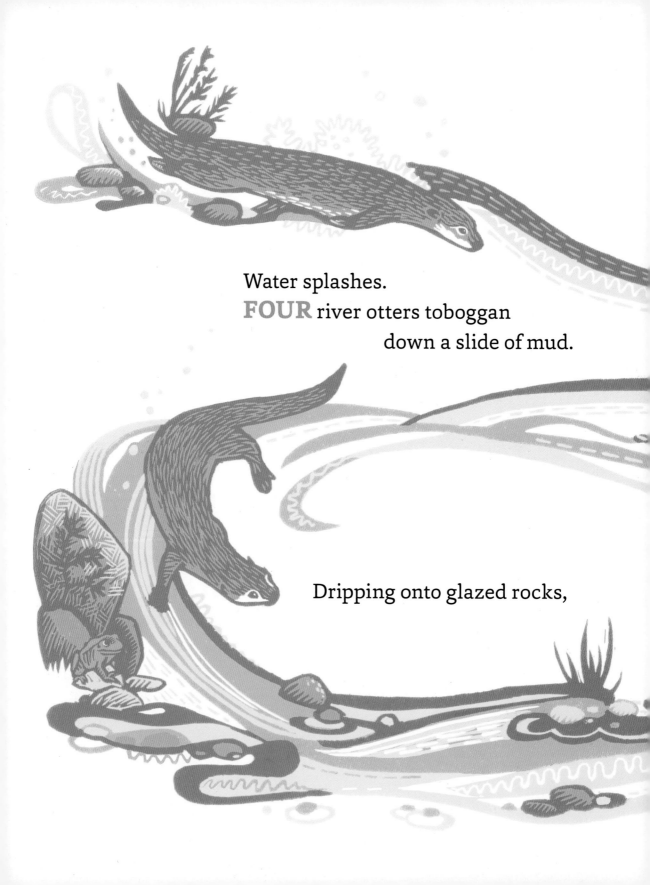

Water splashes.
FOUR river otters toboggan
down a slide of mud.

Dripping onto glazed rocks,

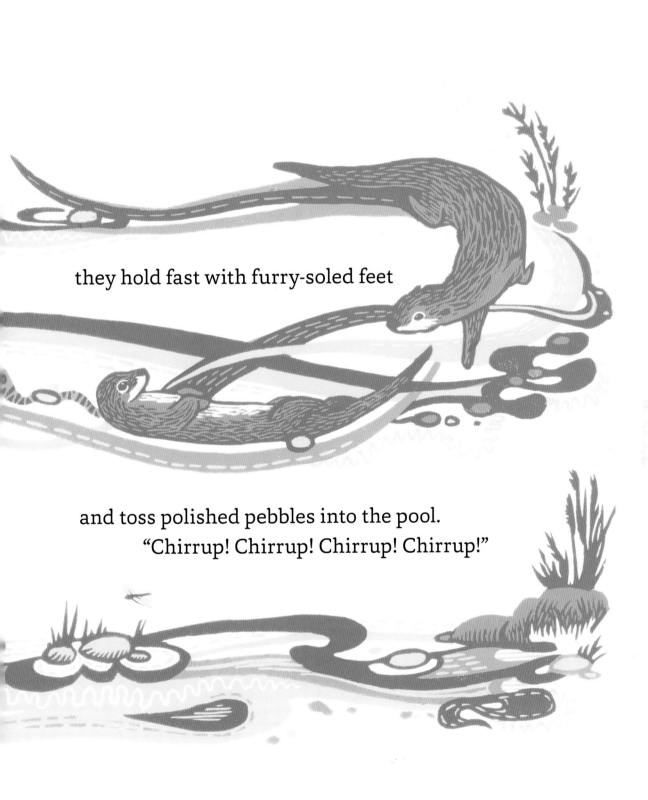

they hold fast with furry-soled feet

and toss polished pebbles into the pool.
"Chirrup! Chirrup! Chirrup! Chirrup!"

Water glistens.
FIVE burrowing owls
pop up from protected holes.

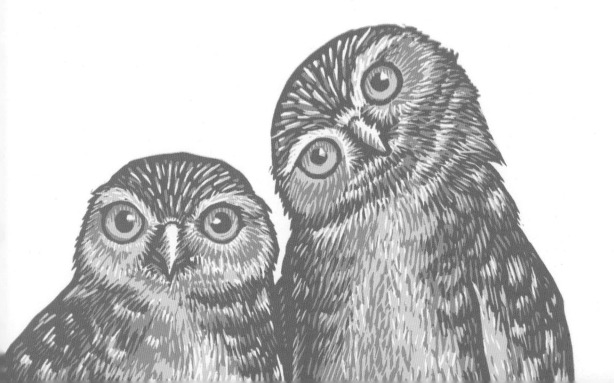

"Hoo-hooo! Hoo-hooo!"

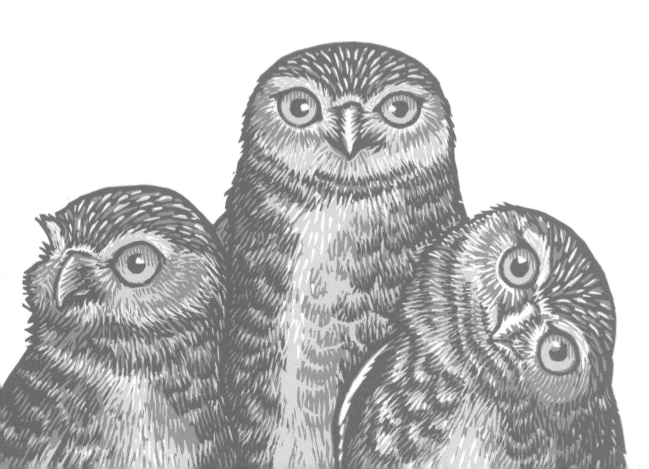

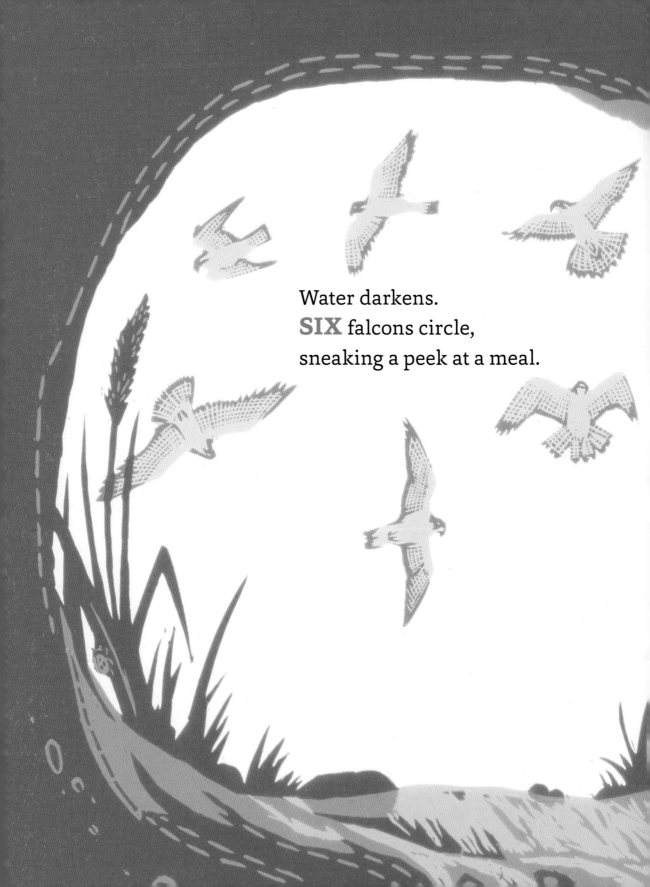

Water darkens.
SIX falcons circle,
sneaking a peek at a meal.

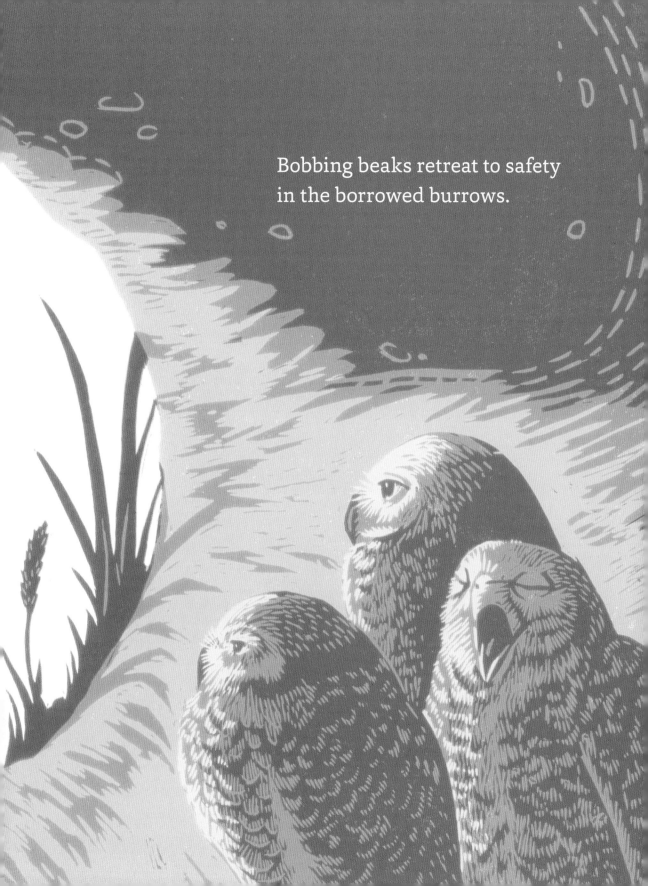

Bobbing beaks retreat to safety
in the borrowed burrows.

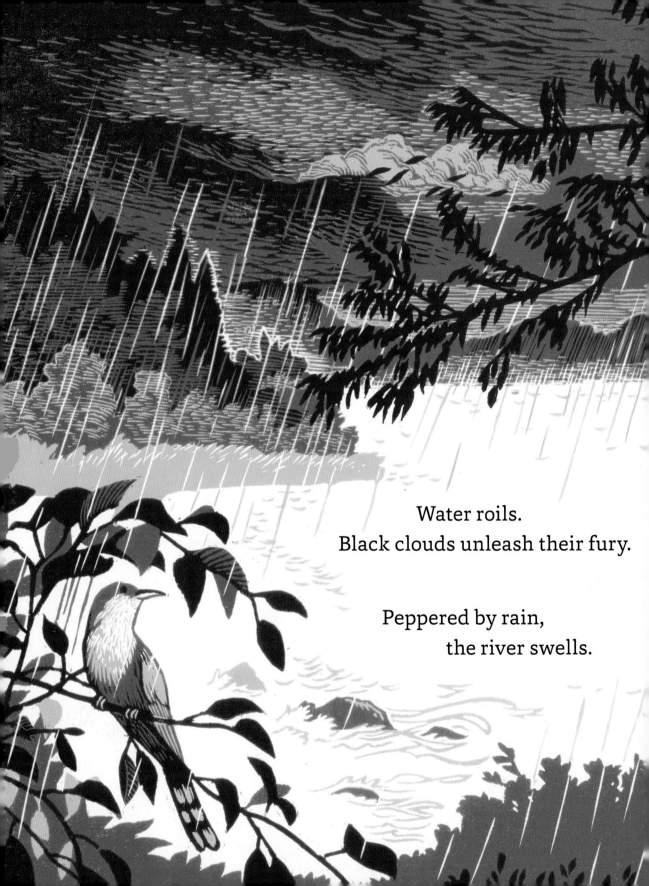

Water roils.
Black clouds unleash their fury.

Peppered by rain,
 the river swells.

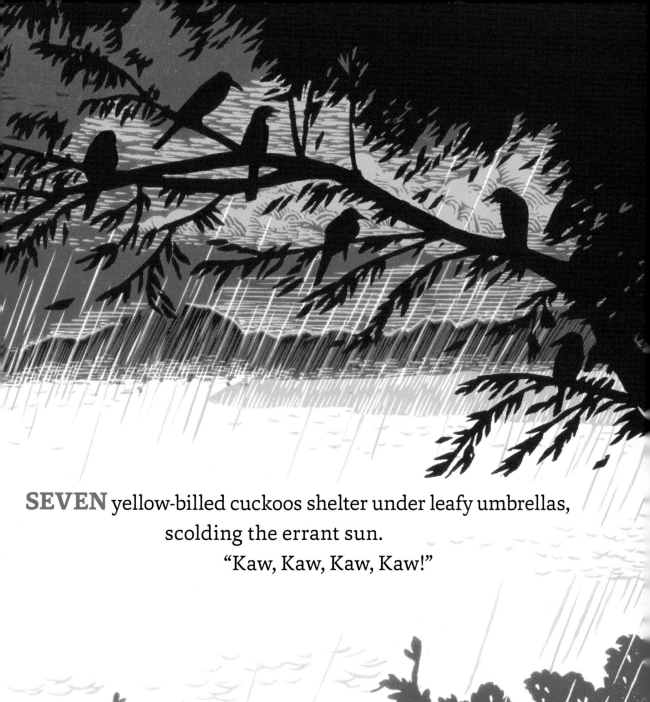

SEVEN yellow-billed cuckoos shelter under leafy umbrellas, scolding the errant sun.
"Kaw, Kaw, Kaw, Kaw!"

Water cascades.
A toppled trunk tumbles by,
catching on a half-buried boulder.

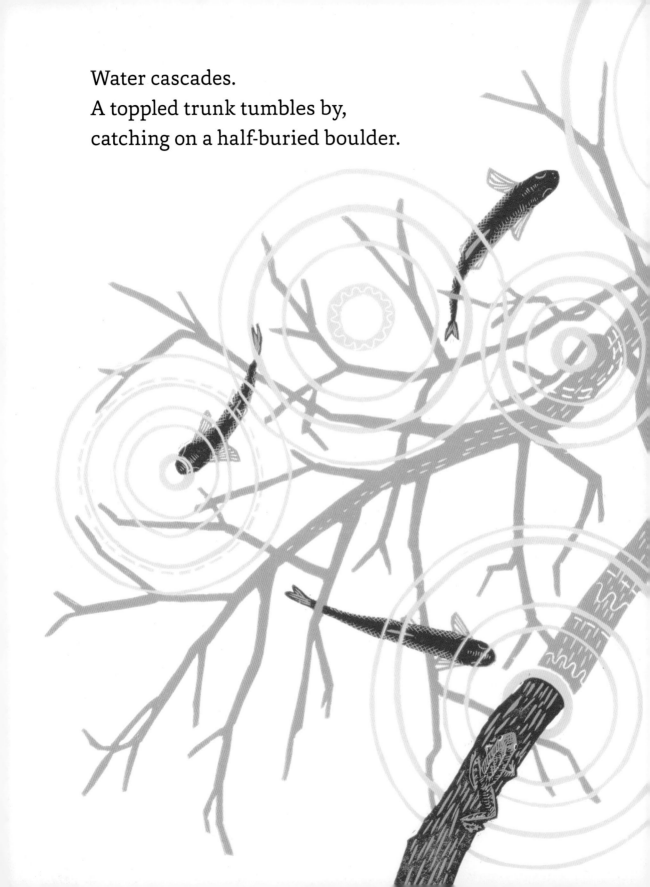

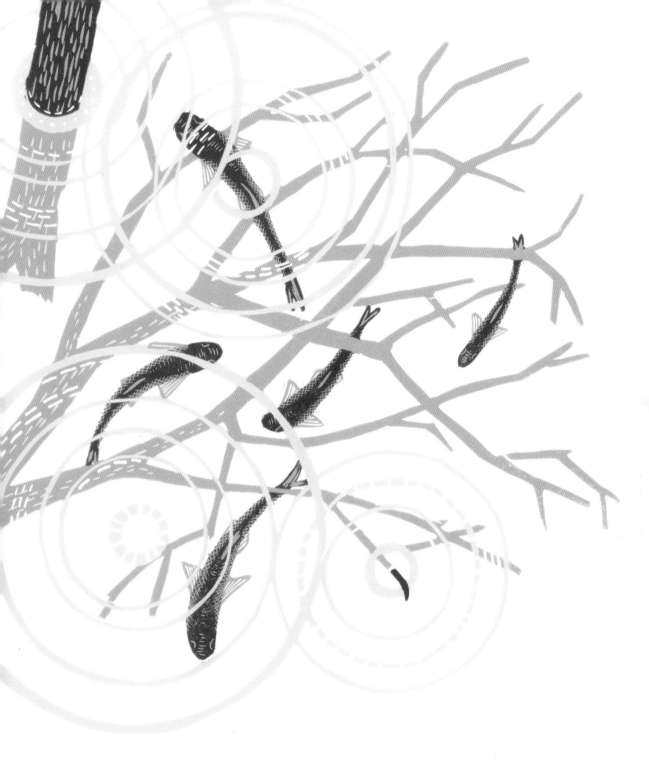

EIGHT pikeminnow find a new home
in the maze of branches below.

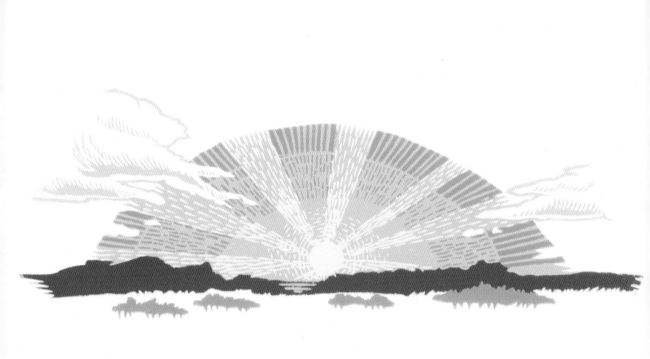

Water glitters.
A brisk wind pushes the storm clouds,
revealing the setting sun.

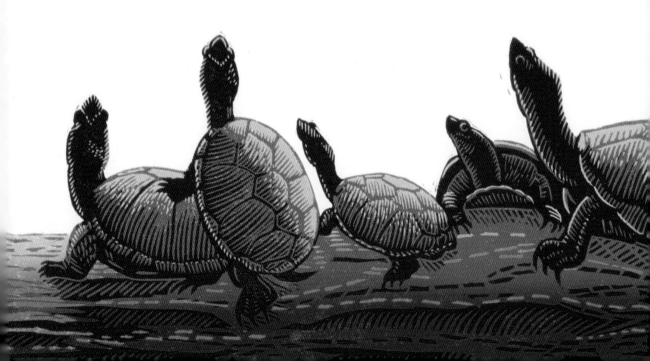

NINE yellow mud turtles stretch out their necks,
sunbathers soaking up the last rays
before leaving their log.

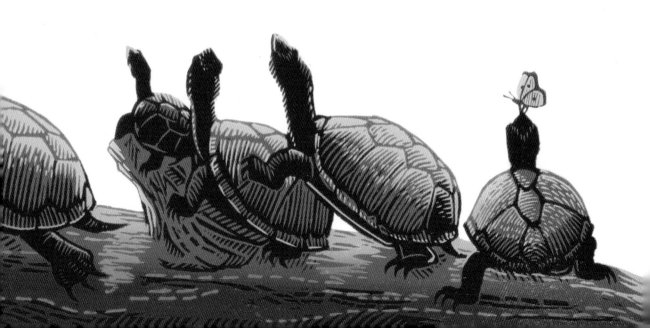

Water flows.
 Dusk falls,

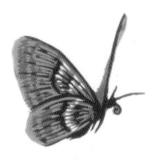

 stealing the day,
 as the mountains swallow the sun.

TEN fritillary butterflies flit,
 flutter,
 and hover,
 sipping nectar
 in a patch of wild columbine.

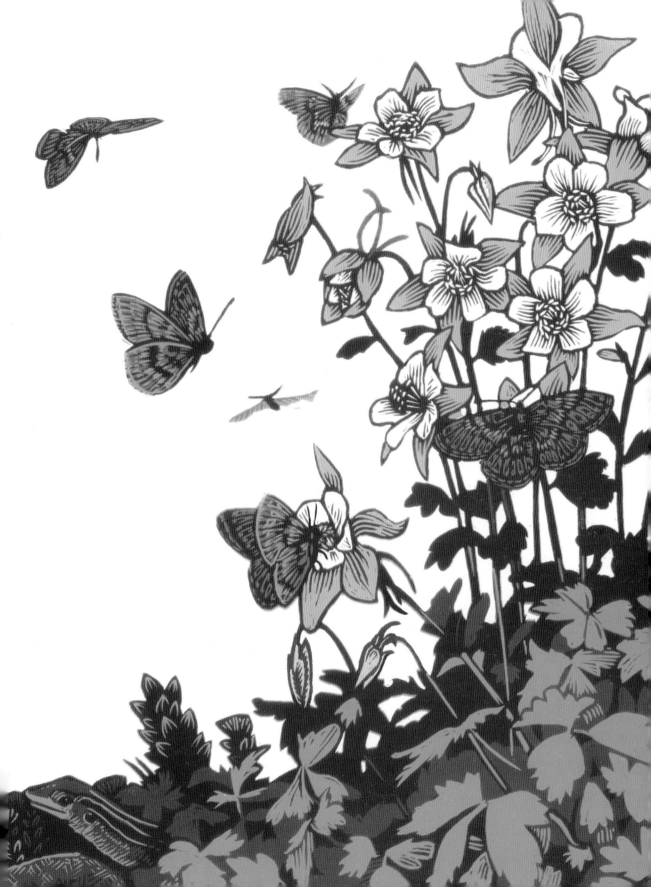

Suddenly—silence.
A silver sliver hangs
in the night sky.

Dreaming of the promise
of tomorrow's sunrise,
water waits.

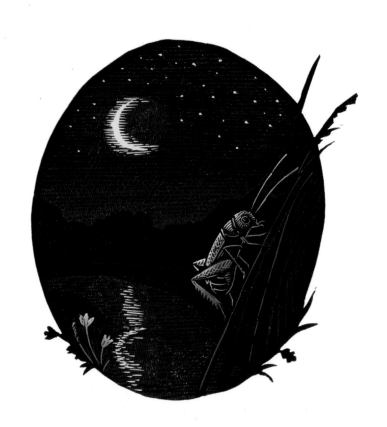

A Glossary of Animals Mentioned

Southwestern Willow Flycatcher: Walk along a riverbank where dense vegetation grows, and you may hear the sneezy *fitz-bew* of the southwestern willow flycatcher. These small perching birds mate for the season and care for their three or four chicks, feeding them a diet of dragonflies, flying ants, and other bugs and insects that they catch in midair or pick off foliage. Southwestern willow flycatchers are endangered because their habitat of dense vegetation along riverbanks has been destroyed by human activities such as dam building, agricultural farming, urban development, recreational usage, and groundwater pumping.

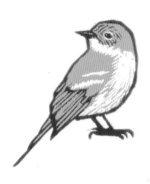

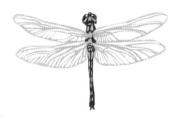

Dragonflies: Watching a dragonfly in flight is like watching a helicopter do spins and loop-de-loops: dragonflies can hover and fly in any direction, including sideways and backward. Dragonflies lay their eggs in water, and after the larvae hatch, they can live underwater for two or more years. And talk about changing clothes—dragonflies molt up to seventeen times as they grow. But even though dragonflies have been on earth for over three hundred million years, some are struggling to survive because of habitat destruction and water pollution where they live and breed. It's important for us to take care of the land and water so that dragonflies stick around for another three hundred million years.

Bonytail Chub: In quiet pools or swift river flows, you might catch a glimpse of the silver, streamlined body of the endangered bonytail chub as it eats insects, plankton, and plant matter. They can live up to fifty years but are on the brink of extinction, and so they are more likely to be found in fish hatcheries. In the 1970s and 1980s, several dozen fish were placed in hatcheries where the species could be preserved. Work is still being done to try to save the bonytail chub, like restoring their natural habitat, building better dams, and monitoring fish populations.

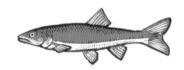

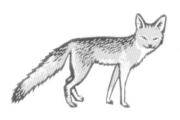

Kit Fox: Observing a kit fox in the wild is something most people will never get to do since these animals are mainly nocturnal (they're awake at night and sleep during the day), although they sometimes leave their den at dawn or twilight. They are the smallest foxes in North America and have large ears and a long, bushy tail that is almost half the length of the fox itself. They can run fast for short distances, but this doesn't prevent coyotes and other predators from hunting them down. Like so many animals in this book, habitat destruction poses a threat to kit foxes—the land they live on is often turned into agricultural fields and roads.

River Otters: River otters are a sentinel species, which means they are highly sensitive to pollution. But where river otters prosper, it means the aquatic habitat is healthy. In 1972, both the Clean Water Act was passed and the usage of a poisonous pesticide called DDT was banned in the United States. River otter populations had been dropping, but in the years since, river otters have been reintroduced around the United States. Thanks to recovery programs, river otters are flourishing in many places. These carnivores will eat just about anything—frogs, snakes, crayfish, turtles, and birds. When coyotes approach, otters chase them away. They chase each other also, sliding on muddy banks and tobogganing down frozen slopes of snow.

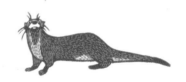

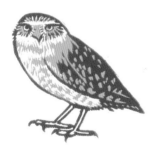

Burrowing Owl: When cowboys saw burrowing owls, they called them "howdy birds" because they seem to nod hello from the entrance to their burrows. These birds mostly hunt at dusk or night, but when feeding their young they hunt during the day as well. They catch flying insects in the air and dive from perches, soar over fields, and use their long legs to run on the ground as they prey on small mammals, birds, snakes, and lizards. They often "borrow" their burrows from other animals, such as prairie dogs, ground squirrels, armadillos, or tortoises. For many years, their populations have declined because of loss of habitat, including burrows the owls depend on.

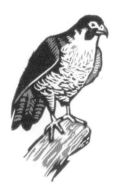

Peregrine Falcon: Do you know which animal is the fastest in the world? The peregrine falcon wins the prize—topping out at 242 miles per hour as it dives to grab its prey. Small rodents and birds had better watch out! When nesting, peregrine falcons tend to return to the same ledge or rocky cliff (called an aerie) to lay eggs and care for their hatchlings. By the 1970s, because of the use of pesticides like DDT, the peregrine falcon had become endangered. At that point, government agencies, private citizens, and concerned organizations began the task of recovery. Today, the peregrine falcon is no longer considered endangered or threatened. Hooray for conservation programs!

Yellow-Billed Cuckoo: Look out, all you large hairy caterpillars! The yellow-billed cuckoo is hunting for you! Caterpillars make up about half of the yellow-billed cuckoo diet, and nestlings need to be fed up to thirty-one times per day. Both parents share in caring for the brood and take turns finding food and feeding them. These long, slim birds live in the canopies of deciduous trees and make a knocking call, which is replaced in summer by cooing. Distinct populations of the yellow-billed cuckoo were officially listed as threatened in 2014 due to loss of riparian forests (wooded areas alongside waterways), their primary habitat.

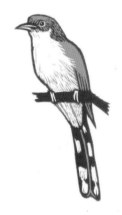

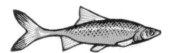

Colorado Pikeminnow: In the past, Colorado pikeminnow would grow to be six feet long and weigh around eighty pounds. Today, they only grow to about half that size. These freshwater fish, which can live up to forty years, have been known to swim over two hundred miles to return to the site of their birth to spawn. The young feed on insects and plankton and prefer mellow backwaters, while adults (they have no teeth!) feed on fish and can live in strong flowing water. Unfortunately, their populations have declined because of loss of habitat, poor water quality, and change in stream flow and water temperatures. They were listed as endangered in 1967.

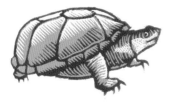

Yellow Mud Turtle: Found in wetlands with sandy areas nearby, the yellow mud turtle spends about as much time on land as in water. They are small (up to six inches long) with olive-colored shells, can live for more than forty years, and eat a variety of snails, fish, crayfish, fairy shrimp, earthworms, and insects. We can help yellow mud turtle populations by protecting their habitats, including the sandy spaces between wetlands that let them easily move around. A wetland that's diverse with native wildlife is also a place where yellow mud turtles can thrive.

Uncompahgre Fritillary Butterfly: In 1978, a new species of butterfly—the Uncompahgre fritillary butterfly—was found in alpine meadows in a small area of the American West, and by 1991 it was listed as endangered. These tiny, brownish-orange butterflies have a two-year life cycle and rely on the snow willow as their host plant (they lay their eggs on its stems, and caterpillars eat the leaves). They are susceptible to trampling by hikers and grazing animals, and so recreational trails and sheep grazing locations in their range have been moved wherever possible. But the rising global temperatures threaten to push these butterflies farther up into the high country, potentially making it harder for them to survive.

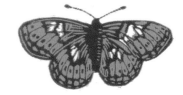

Did You Also Spot These Animals?

Elk

Least chipmunk

Ladybug

Six-lined racerunner

Plains leopard frog

Bullfrog

Clouded sulphur butterfly

Categories of Conservation

Species of Concern: These animals and plants might need conservation efforts. Citizens and conservation groups often work to protect them, but these species don't yet have legal protection.

Threatened: These animals and plants are likely to become endangered in the future. These species receive protection under the Endangered Species Act.

Endangered: These animals and plants are in danger of becoming extinct. These species receive protection under the Endangered Species Act.

Extinct in the wild: This means a species exists only in captivity, such as in zoos or hatcheries. The species is at risk of becoming extinct.

Extinct: This means that no known individuals of a species are alive.

Factors that Endanger or Threaten Species

- Habitat loss and habitat degradation, due to things like urban sprawl, camping, and natural disasters
- The spread of invasive species (that is, nonnative species that negatively affect the ecosystems they become part of)
- Global warming (also called climate change)
- Chemical pollution of habitats
- Unsustainable hunting
- Disease

About the Author and Artist

Vivian Kirkfield's career path is paved with picture books. Whether shelving books in a children's library, reading stories with her kindergarten classes, or writing tales for children around the globe, Vivian has always worked to help kids become lovers of books and reading. She lives in the quaint New England village of Amherst, New Hampshire, where the old stone library is her favorite hangout and her young grandson is her favorite board game partner. To find out more about her upcoming books, visit www.viviankirkfield.com.

Mirka Hokkanen has always loved drawing animals. While growing up in Finland, her very favorite things to sketch were horses. When she got a little older and went to college, she learned about printmaking and continued creating art with animals as linocuts and wood engravings (types of printmaking). This is the first picture book she has illustrated with wood engravings. To learn more about Mirka and printmaking, or to find fun activities to go along with this book, visit www.mirkah.com.